THOMAS WOOD

25 Years of Printmaking

THOMAS WOOD

25 Years of Printmaking

Essay by Lois Allan

WHATCOM MUSEUM
of History and Art

Bellingham, Washington

This catalogue has been published
in conjunction with the exhibition
Thomas Wood
25 Years of Printmaking
Whatcom Museum of History and Art
31 October 1998–7 February 1999

All impressions reproduced in this
publication were printed by Thomas Wood
Art work photographed by Rodrigo del Pozo
Design by Craig Beverly and Lisa Harris
Printed by Ash Creek Press, Portland, Oregon

Whatcom Museum of History and Art
121 Prospect Street
Bellingham, Washington 98225
360.676.6981

ISBN 0-938506-05-6
Library of Congress Catalog Card Number:
98-88361

Published in association with
Lisa Harris Gallery
1922 Pike Place
Seattle, WA 98101
206.443.3315

Printed in the United States

COVER:

Night-blooming Flowers II
1997, edition of 80
etching, aquatint
9" × 12"

FRONTISPIECE:

Fish Nor Fowl
1988, edition of 25
etching, woodcut
6" × 7½"

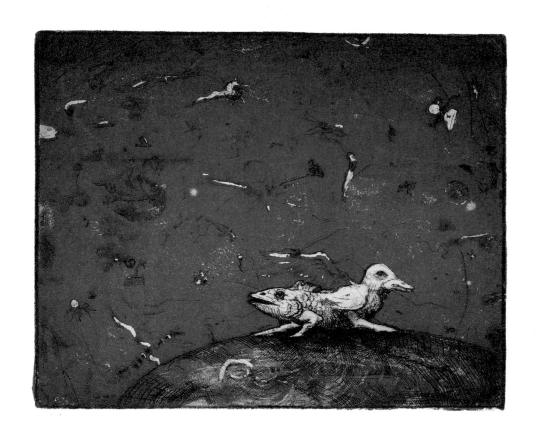

I was rinsing out a sieve in a pond one day and caught a little monster as long as my finger here, with gills and a tail. Thinks I--it's a fish! Then I take another look at it--and I'll be blessed if it didn't have feet! It wasn't a fish and it wasn't a reptile--the Devil only knows what it was! That's just what you are. What class do you belong to?

—Anton Chekhov

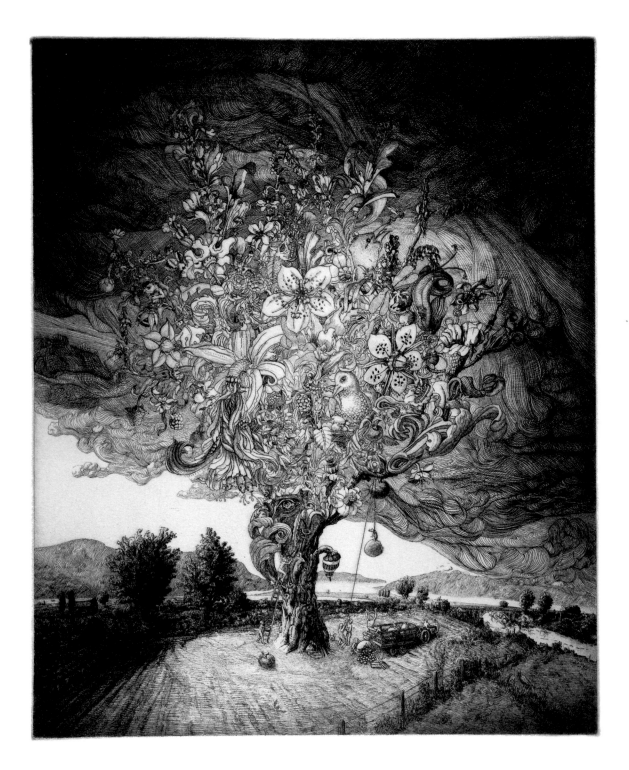

Harvesting the Magic Tree
1982, edition of 145
etching
18″× 14″

ACKNOWLEDGEMENTS

The Whatcom Museum is pleased to present a retrospective exhibition of prints by Thomas Wood on the occasion of his 25th anniversary as a printmaker. Comprising works from the period 1973 to 1998, the exhibition includes key examples from the artist's diverse printmaking techniques, from mezzotint and woodcut to a wide range of intaglio methods. Thomas Wood's technical virtuosity is much admired. Yet it is his personal, highly original vision which leaves viewers with an indelible impression.

The idea of an exhibition celebrating twenty-five years of Wood's printmaking was conceived by the late Doug Chapman, of Lucia Douglas Gallery, Bellingham. He was assisted in early curating by the artist and John Olbrantz, then with the museum. Lois Allan's essay for the catalogue provided focus at a critical time. Lisa Harris of Lisa Harris Gallery in Seattle worked with the museum on exhibition planning, particularly the development of this important catalogue. A special thank you to her for her invaluable contribution of time and effort.

The Whatcom Museum and Thomas Wood would like to express sincere thanks to the many collectors and galleries who have made possible the publication of this catalogue. Their interest in art historical documentation and support of the artist's work is truly appreciated. A list of donors may be found on page 48 of the catalogue.

A retrospective of the work of such a prolific artist must necessarily be selective. We feel that the images nonetheless convey the full range and emotive power of his prints. This exhibition of twenty-five years of Thomas Wood's imaginative printmaking is dedicated to Doug Chapman.

Mary Pettus
Director, Whatcom Museum

Scott Wallin
Chief Curator, Whatcom Museum

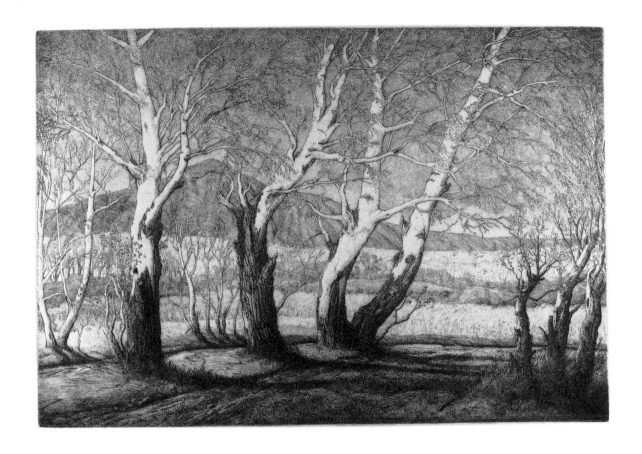

Large Cottonwoods
1988, edition of 100
etching
13″ × 18″

ABOVE RIGHT:
Angels on the Head of a Pin
1977, edition of 5
mezzotint
2″ × 2″

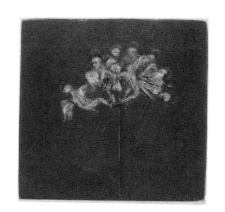

Visually compelling though they are, Thomas Wood's prints speak first, gently but insistently, to our emotions. Like his paintings and pastel drawings, they infuse natural appearance with a sense of the marvelous. More intimate in scale and concept than his other works, the prints convey a fanciful world filled with opposites: beauty and the grotesque, delight and foreboding, humor and gravity. In the broadest sense of the term Thomas Wood is a visionary artist, one who experiences the world from an intensely felt subjectivity. Early in the century, a now forgotten visionary painter, James W. Parry, exclaimed, "It will be questioned when the sun rises, do you not see a round disk of fire somewhat like a guinea? Oh, no, no! I see an innumerable company of the heavenly host crying, 'Holy, holy, holy, Lord god Almighty!'"[i] Although he does not share Parry's religious fervor, Wood, too, overlays natural phenomena with human desires and fears. Drawing equally from his own psychic experience and nature, and using the exacting processes of printmaking, he has created a body of work that elicits the mystery and ongoing suspense in each human's life.

In this exhibition, a selected body of prints produced from 1973 to 1998, Wood's singular vision is demonstrated in images that graphically connect the recognizable, real world to the invisible "world" within his imagination. The prints' extraordinary visual clarity intensifies their ambiguous, preternatural connotations. Wood's natural surroundings provide the subjects—land and sea, fish, flowers, humans—which become the taking off point for his chimerical images. A longtime resident of Bellingham, Washington, he is surrounded by spectacular forests, mountains, streams, and the Pacific ocean. The environment is more than inspiration, however; it is also the basis of the region's economy. From such dependency, western Washington residents share with humans since time immemorial a mix of psychological associations with nature that include awe and delight as well as desire and fear. Wood evokes these timeless and universal mystical aspects of nature

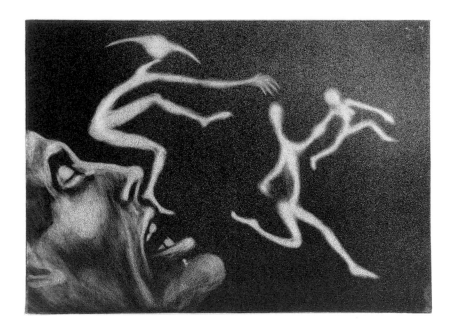

Fever Dream
1973, edition of 5
aquatint
8½″ × 12″

in his art. They form the backdrop for explorations of matters that concern him personally, most of all, his relationship to certain individuals, to art history, to literature, and to the environment. Such issues are rarely overt, but rather, stated poetically in metaphor and symbol.

In his use of realistic representation, Wood belongs to a distinguished artistic continuum. Like Albrecht Dürer (1471-1528), he fills compositions with explicit, detailed images and suggested narratives. Like Hieronymous Bosch (1450-1516), he knows and exploits the psychology of fantasy. Like Francisco Goya (1746-1828) he confronts the grotesque in human nature. Lastly, he shares with Alfred Pinkham Ryder (1847-1917) a penchant for dramatizing forms in nature—clouds, the moon, and vegetation—in order to heighten mood. These influences are contemporized in his work by incongruity, irony, and whimsy—all characteristics of late twentieth century art—that play through the historical and personal references.

The earliest print in the exhibition, *Fever Dream*, an aquatint of 1973, contains the seeds of the style and dream-like content that are fully developed in later work. The spectral, silhouetted figures emanating from the profiled male head in *Fever Dream*, as

well as the angels in *Angels on the Head of a Pin,* 1977, are precursors of much more specific spirit figures such as those in *Bearwoman,* 1986, and *Mermaids,* 1994. By the 1980s, fish with human attributes, both visual and in personality, appeared in such prints as *Sculpins* and *The Great Sculpin.*[ii] Illustrating the stylistic evolution of the fish theme over time are two prints with the same title, *Kissing Fish.* In the 1978 etching, the two fish appear as quick line drawings on white paper; in the 1997 mezzotint, a more complex composition and detailed drawing feature the fish at night captured

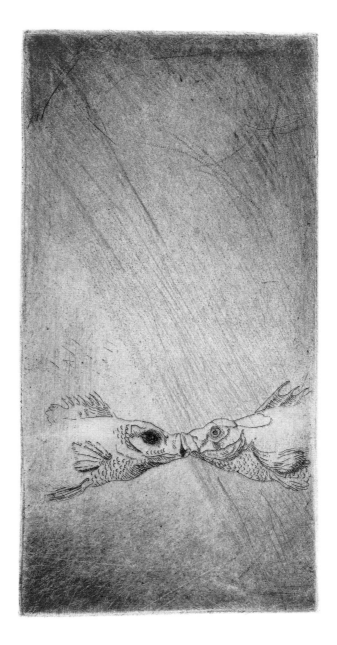

Kissing Fish
1978, edition of 100
etching
8" × 4"

within the bare branches of a tree. Wood's playful mocking of romantic relationships in these prints gets even fuller treatment in *Bacchanal* in which very strange—even by early Greek standards—satyrs and nymphs wear current fashions in sneakers, bras, and panties as they cavort in a Dionysian setting.

Wood's love for the landscape genre sometimes takes form in closely observed and meticulously rendered scenes such as that of *Large Cottonwoods.* More often, though, the hallucinatory quality that marks *The Wanderer* is conveyed by turbulent clouds, moonlight and darkness, skewed perspectives, and mysterious relationships. Among the most imaginative of the landscape subjects is *Harvesting the Magic Tree.* Here Wood gives full play to both his imagination and his artistic virtuosity. The tree, with its myriad "fruits," can be seen as a metaphor for planet Earth, offering far more than the human harvesters can take from it. Will they harvest only what they need? Or will they plunder, unheeding of the consequences to the tree? This etching is a *tour de force* of draftsmanship, contrasts of light and dark, and illusionary space.

As much as his academic training, Thomas Wood's travels, especially his visits to European museums and the Queen Charlotte Islands, have influenced the style and thematic base of his prints. From the European masters he absorbed graphic

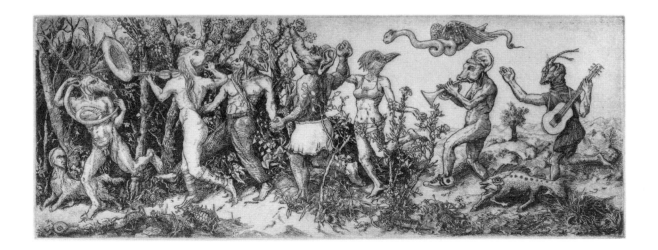

Bacchanal
1983, edition of 100
etching
4½″ × 12½″

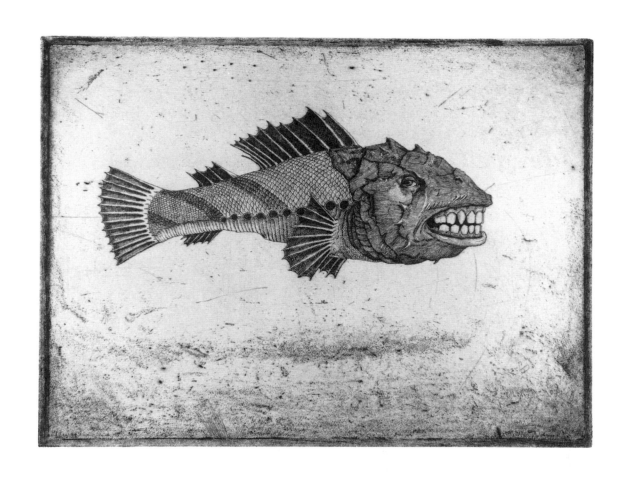

The Great Sculpin
1994, edition of 100
etching
9" × 12"

clarity and metaphysical content; from the native culture of the Queen Charlotte Islands, the importance of allegory and totemic representation. This conceptual base is quite different from that employed in his paintings and pastels. Human presence in a natural environment is the underlying theme of the paintings, while a straightforward rendering of the landscape marks the pastel works. It is in the intimacy of the prints (in both size and content) that his imagination enjoys full rein. Lacking the extra charge inherent in the rich colors of the paintings and pastels, the formal strength of the prints lies in extraordinary draftsmanship, intense composition, and the finely controlled variation in tonalities. Color, when employed, is subdued, supporting but not dominating primary significations.

Because process and paper are inescapably visible in prints, they are crucial to the success of the finished print. The gray, handmade paper on which *Night Painter* is printed demonstrates the ability of the paper to enhance the mood of the picture. In this, as in all prints, the paper's texture, color, and weight, along with the printing process, form the particular aesthetic of print art. In Wood's case, the processes most often used are the various intaglio processes; for the most part, etching, aquatint, and drypoint. In *Night Blooming Flowers II,* for example, the deep black background was obtained by aquatint, the means by which overall tonality is produced. The flower-filled foreground is the result of drawing on an asphaltum coated plate with an etching needle.

A trained printer who does his own printing, Wood works in a fully equipped, comfortable studio located on the property of his hillside home. Here he creates his images on copper plates, then produces editions as small as five and as large as two hundred. Like all printmakers, he is attracted to the physicality of printmaking and to the alchemy that results in the printing press's fusion of ink, images, and paper. The true magical transformation occurs, however, when the products of Thomas Wood's fertile imagination and proficient hand generate in us a wholly unexpected but irresistible experience of a world we thought we knew.

Lois Allan

[i] Quoted in *The Eccentrics and Other American Visionary Painters,* Abraham A. Davidson, p. 159

[ii] It should be noted that the second definition in Webster, after identifying sculpins within the Cottidae family, is "A worthless creature."

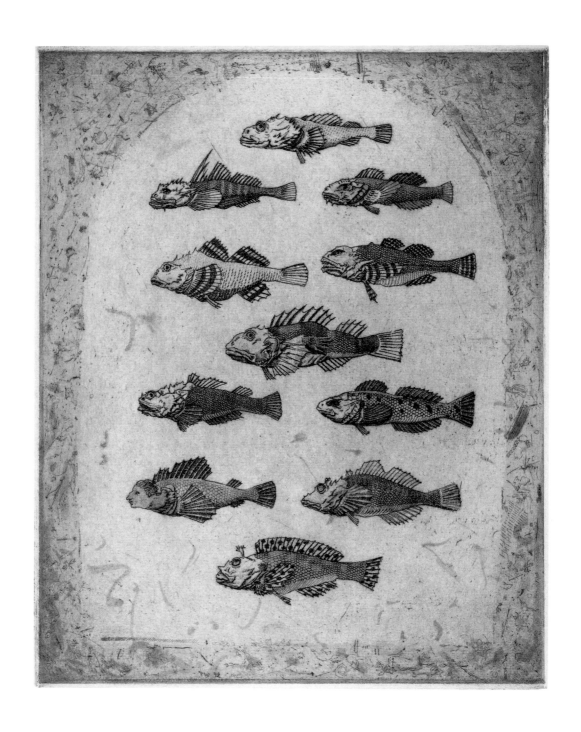

Sculpins
1992, edition of 50
etching, chine collé
12″× 9½″

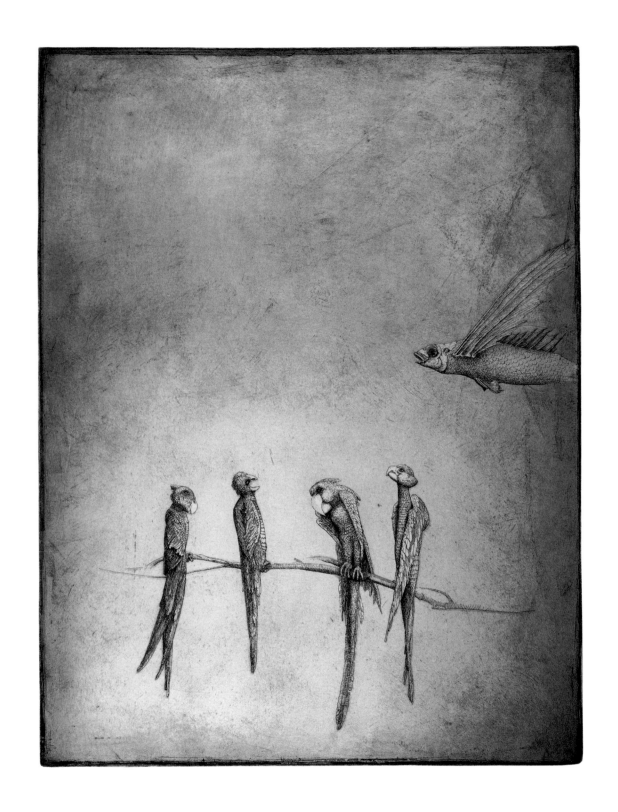

Parrots
1979, edition of 20
etching, woodcut
23½″ × 17¾″

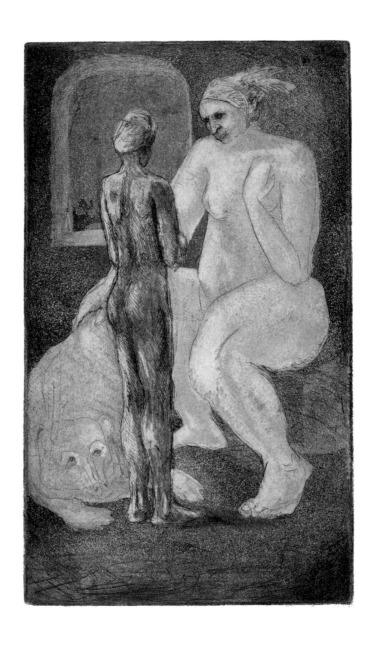

Bearwoman
1985, edition of 10
etching, aquatint
11″ × 6½″

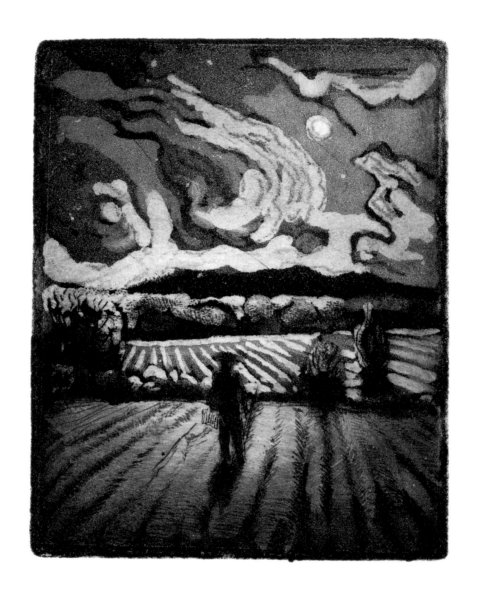

Night Painter
1997, edition of 20
aquatint, chine collé
7″ × 6″

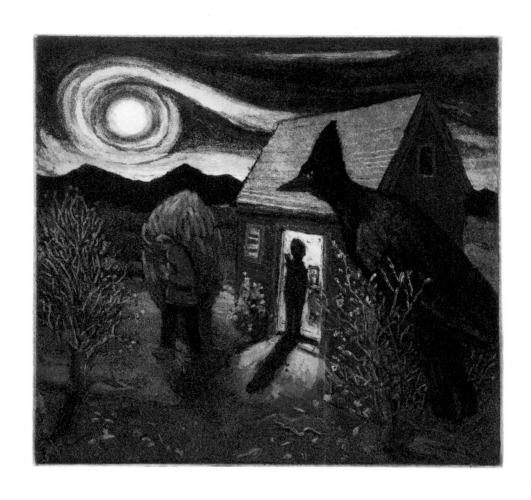

The Wanderer
1998, edition of 80
etching, aquatint
7″ × 8″

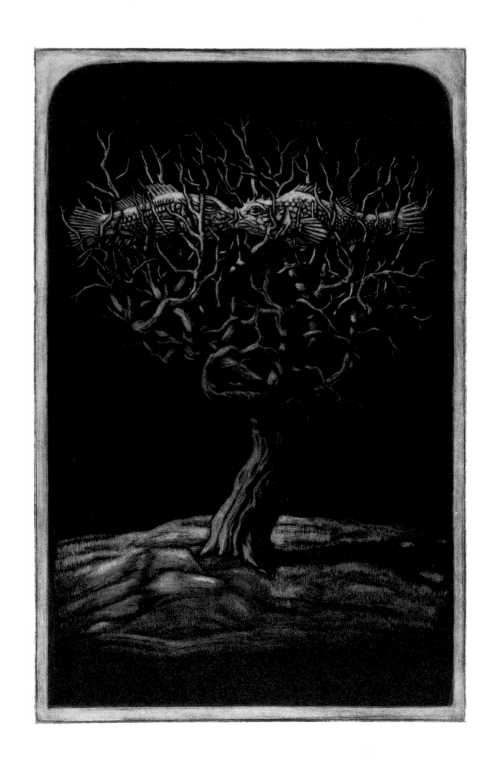

Kissing Fish
1997, edition of 60
mezzotint
12″ × 8″

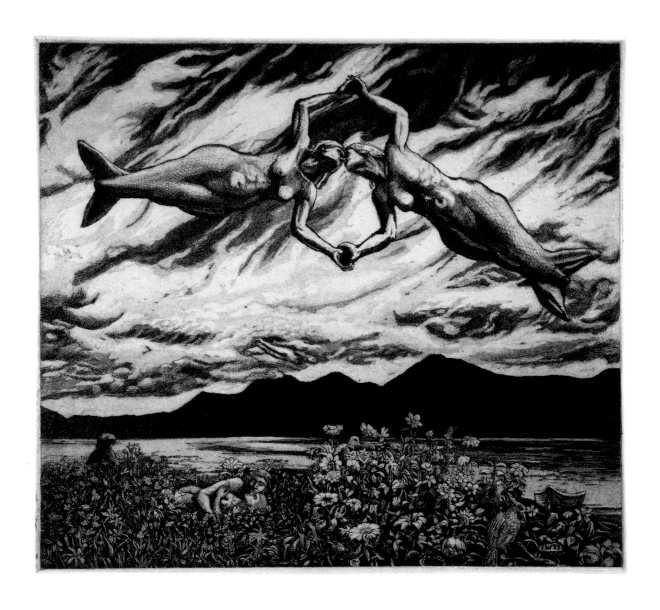

Mermaids
1994, edition of 50
etching, aquatint
10″ × 11¼″

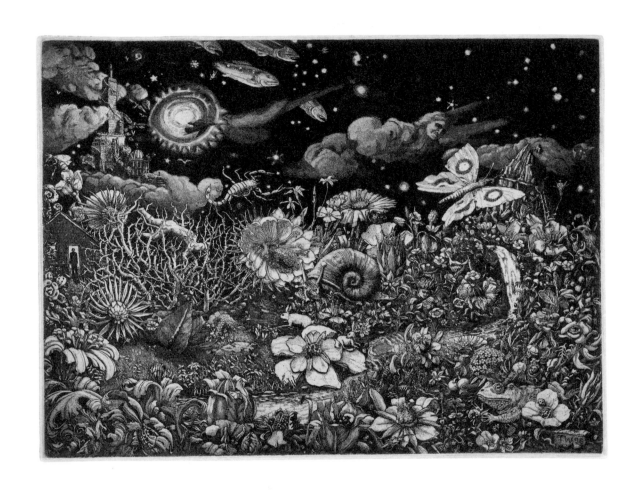

Night-blooming Flowers II
1997, edition of 80
etching, aquatint
9″ × 12″

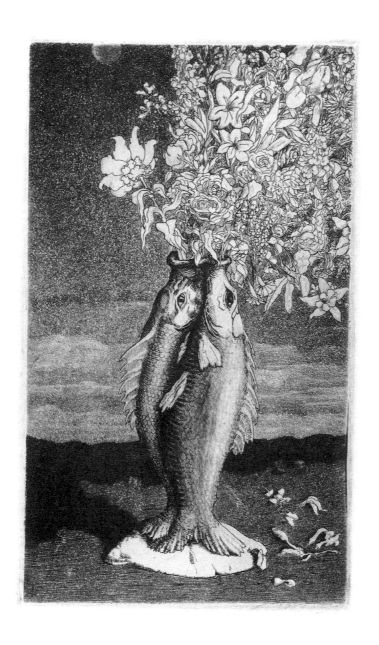

Fish Vase
1981, edition of 100
etching, aquatint, chine collé
7" × 4½"

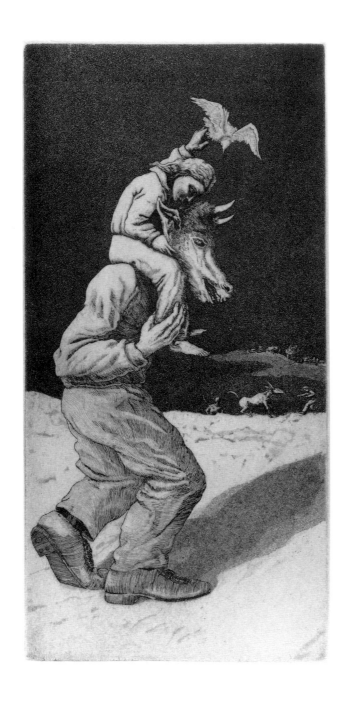

Beasts of Burden
1986, edition of 100
etching, aquatint
14″ × 7″

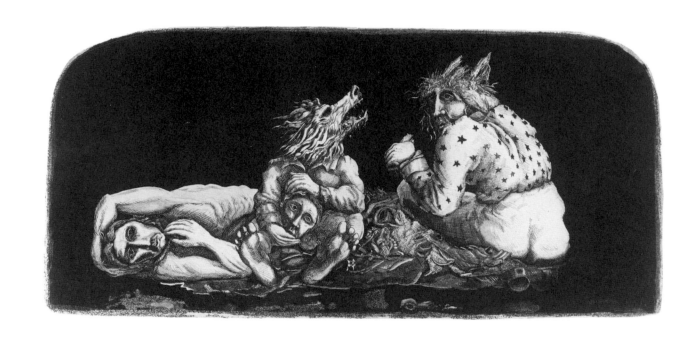

Some Beasts Will Eat Anything
1986, edition of 100
etching, aquatint
7½″ × 14″

The Artist Creates Himself
1994, edition of 10
etching
3¼" × 2½"

The Young Icarus
1988, edition of 15
drypoint
12″ × 9″

Big Fish Eat Little Fish
1980, edition of 50
etching
4″ × 2″

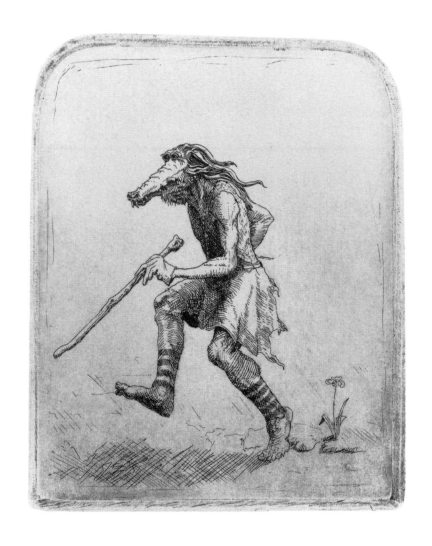

Alligator Man
1981, edition of 100
etching
5" × 4"

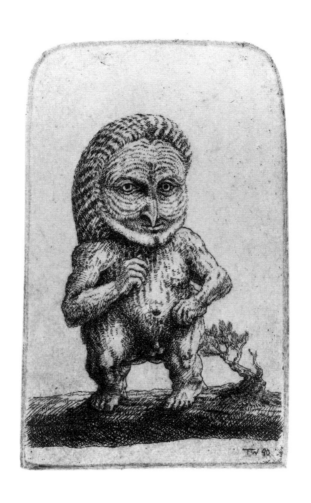

Endangered Species
1990, edition of 100
etching
4½″ × 3″

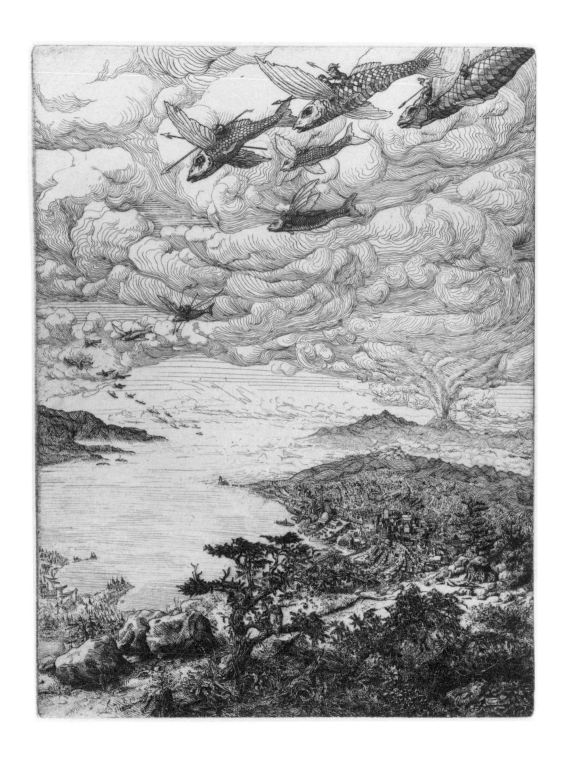

Flight of the Warriors of the Western Ideology
1987, edirion of 100
etching
12½″ × 9″

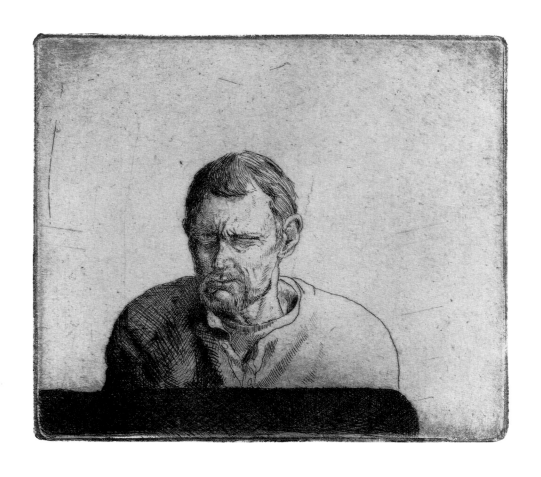

Portrait of Tom Sherwood
1983, edition of 35
etching, chine collé
6″ × 6½″

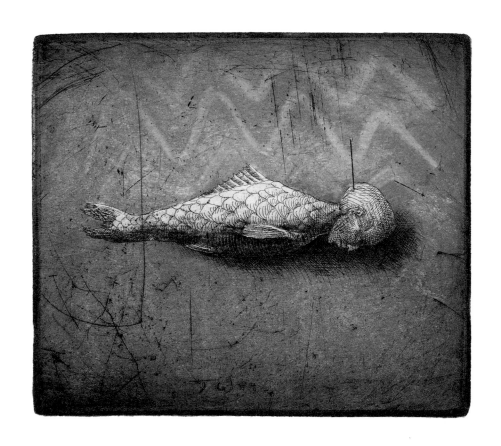

The Little Fish
1984, edition of 50
woodcut, etching
5½" × 6"

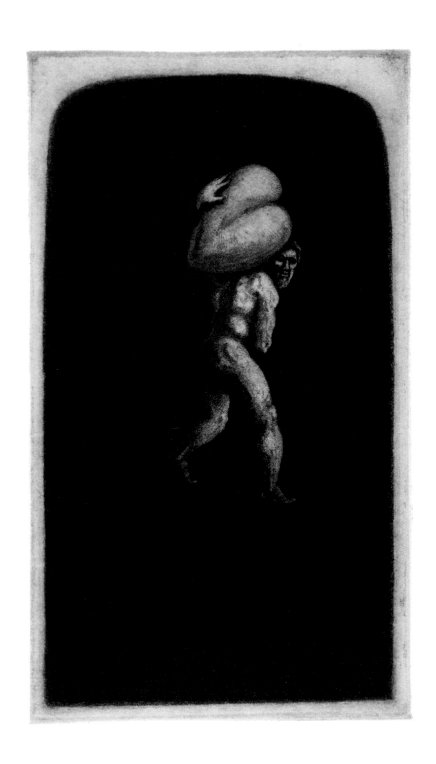

Heart Thief
1989, edition of 100
etching, aquatint
10½″ × 6″

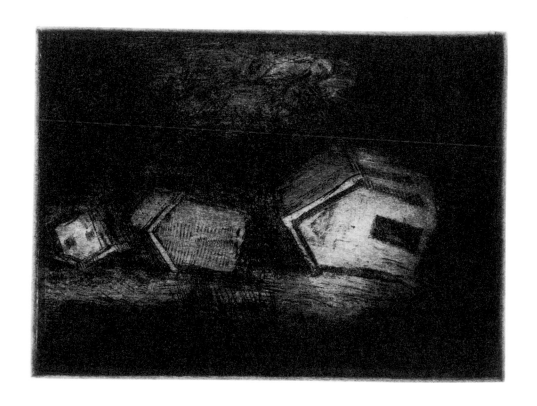

Storm
1991, edition of 22
etching, aquatint, chine collé
4½″ × 6″

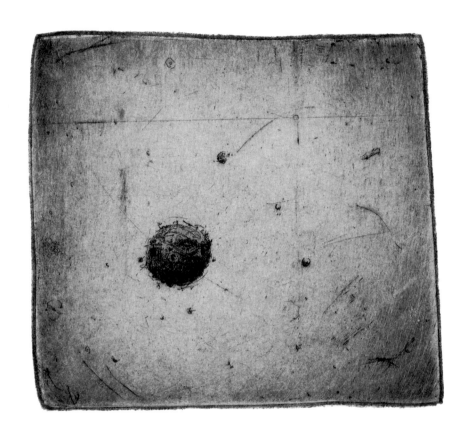

The Ancient
1995, edition of 50
etching
4¼″ × 4½″

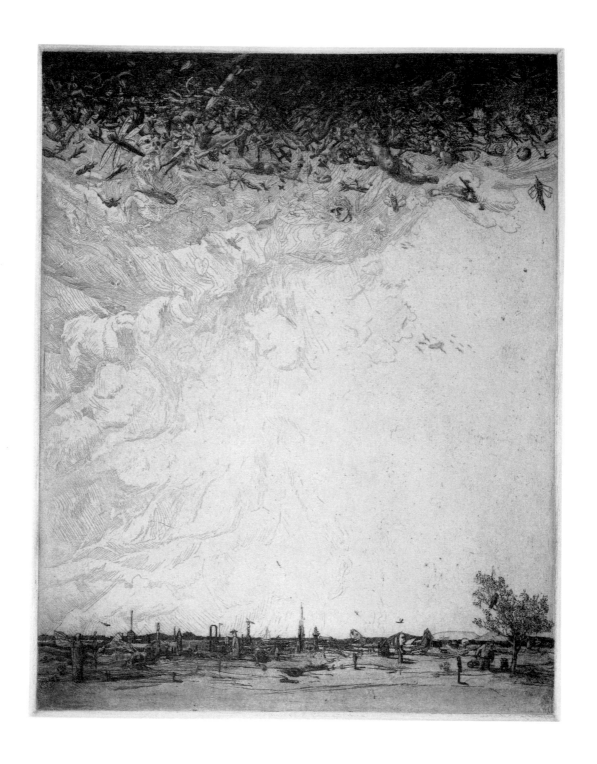

Creatures of the Sky
1995, edition of 100
etching
15″× 12″

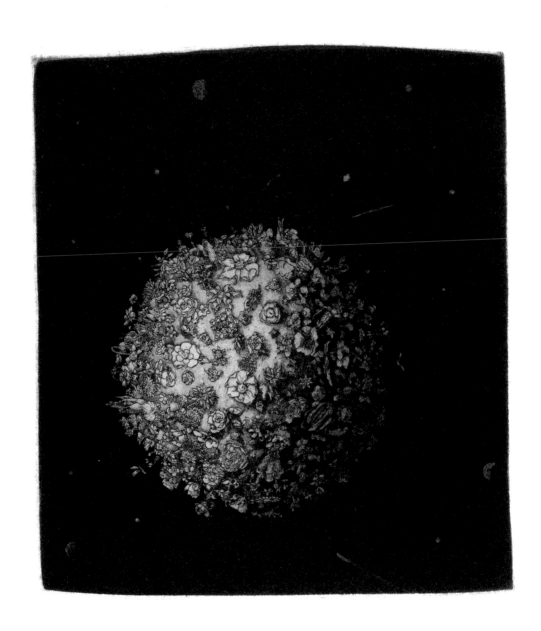

Garden Planet
1995, edition of 75
etching, aquatint
7¼″ × 6¼″

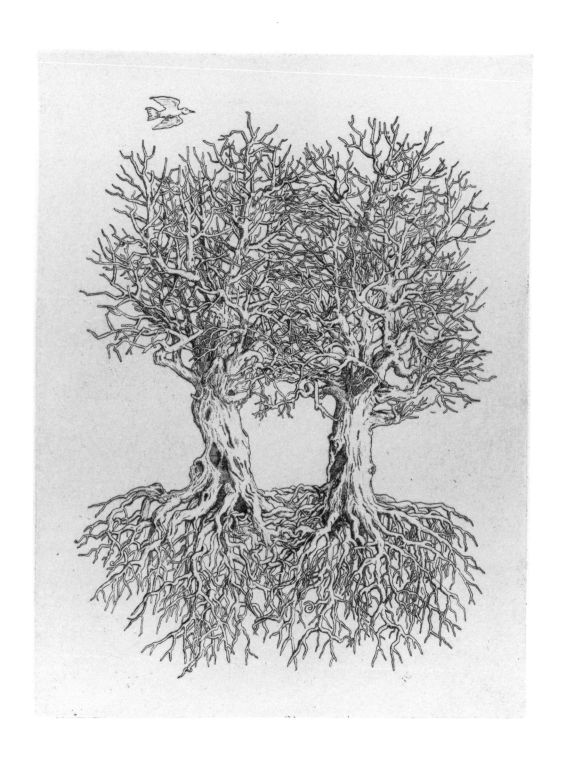

Two Trees
1997, edition of 50
etching
12″ × 9″

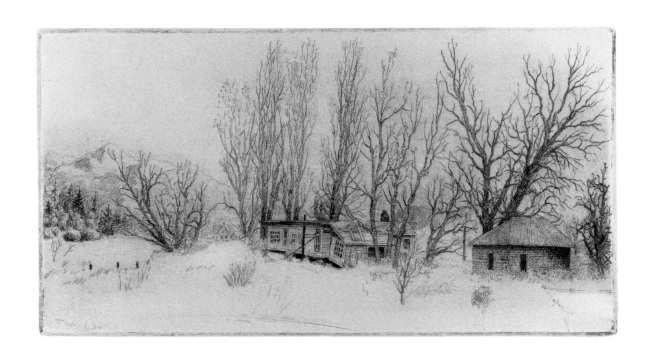

Old House with Poplars
1983, edition of 50
etching
4½″ × 8½″

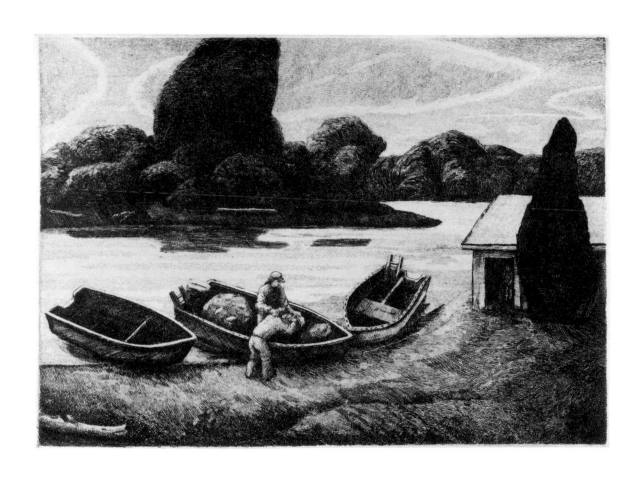

Fishermen on the Nooksack
1991, edition of 50
etching
8″ × 11″

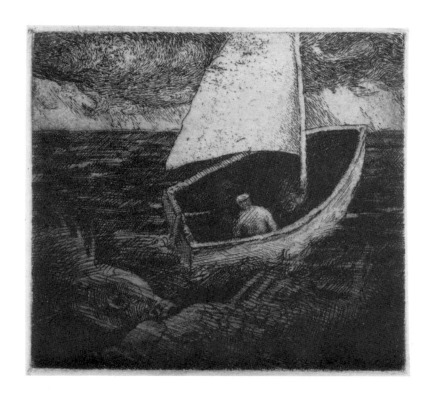

Sailboat
1992, edition of 100
etching
4″ × 4″

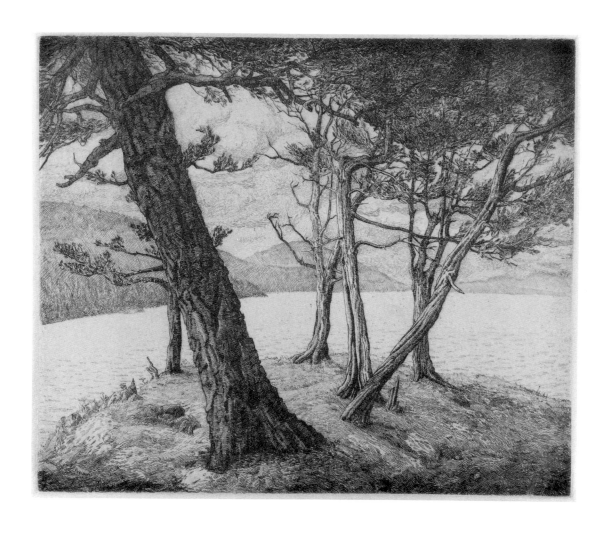

Madrona Point
1992, edition of 100
etching
7" × 8"

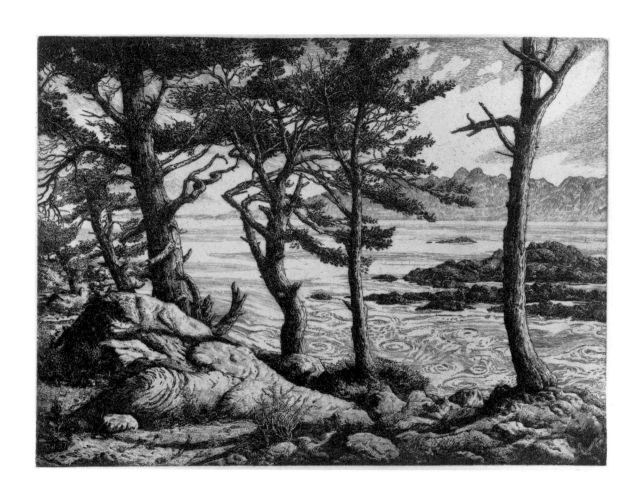

Shark's Reef
1997, edition of 200
etching
9″ × 12″

BIOGRAPHY

THOMAS WOOD

Thomas Wood was born in Richland, Washington, in 1951. He attended Washington State University, Pullman, from 1970 to 1972 and Cornish Institute, Seattle, in 1974. He earned his Bachelor of Fine Art from Fairhaven College of Western Washington University, Bellingham, in 1980.

Travel and working sojourns include Europe (1973), the Queen Charlotte Islands, British Columbia (1985), and the Netherlands (1993). In 1980 he served as apprentice to master printmaker Luigi Arcuri of the *Accademia delle Belle Arti*, Florence. Thomas Wood has resided in Bellingham, Washington since 1973.

Photo by Pam Brownell

SOLO EXHIBITIONS

1998 "Pastels and Oils", Lisa Harris Gallery, Seattle, Washington

1997 "New Prints," Quartersaw Gallery, Portland, Oregon
"Selected Prints," Lisa Harris Gallery, Seattle, Washington

1996 "Recent Pastels, Oils and Etchings," Lisa Harris Gallery, Seattle, Washington
"New Etchings and Monoprints," Quartersaw Gallery, Portland, Oregon
"Prints and Paintings," B. Beamesderfer Gallery, Highland Park, New Jersey

1995 "Recent Work," Lisa Harris Gallery, Seattle, Washington

1994 "Pastels," Lisa Harris Gallery, Seattle, Washington
"Oil Paintings from Holland," Lucia Douglas Gallery, Bellingham, Washington
"Monotypes and Drawings," Fine Impressions, Seattle, Washington

1993 Vermeer Gallery, Nantes, France
B. Beamesderfer Gallery, Highland Park, New Jersey

1992 "Pastels, Oils and Prints," Lisa Harris Gallery, Seattle, Washington

1991 "Pastels," Lisa Harris Gallery, Seattle, Washington
Fine Impressions, Seattle, Washington

1989 Blue Horse Gallery, Bellingham, Washington

1988 Hartness/Schoos Gallery, Seattle, Washington
"Etchings and Pastels," Anacortes Art Gallery, Anacortes, Washington

1981 "Prints and Drawings," Chrysalis Gallery, Western Washington University, Bellingham, Washington

1978 "Etchings," Viking Union Gallery, Western Washington University, Bellingham, Washington

SELECTED GROUP EXHIBITIONS

1998 "Garden Variety Show," Lisa Harris Gallery, Seattle, Washington

1997 "Selected Prints," Lisa Harris Gallery, Seattle, Washington
"Bio-Adversity," Cornish College of the Arts, Seattle, Washington

1996 "A Collective Endeavor: ArtFair/Seattle '92 to '95," Seafirst Gallery,
Seattle, Washington
"Northwest International Art Competition," Whatcom Museum of History
and Art, Bellingham, Washington

1995 "Printmakers' Exhibit," Northwest Departures Gallery, Anacortes, Washington
"New Paintings–Joseph Goldberg and Thomas Wood," Lucia Douglas
Gallery, Bellingham, Washington
Stone and Press Galleries, New Orleans, Louisiana

1994 "Languages of Landscape," Washington Center for the Performing Arts,
Olympia, Washington
"Oil Painting–Thomas Wood, Clayton James, John Cole, Ed Kamuda,
Lucia Douglas Gallery, Bellingham, Washington
Soho Coho Gallery, Ketchikan, Alaska

1992 "Print Invitational," Quartersaw Gallery, Portland, Oregon

1991 Fletcher Gallery, Santa Fe, New Mexico
Blue Horse Gallery, Bellingham, Washington

1990 "Partners in Art," Nakhodka Museum, Nakhodka, USSR
"Bellingham School," Mercer Island Art Gallery, Mercer Island, Washington
"Thomas Wood, Guy Anderson, Jay Marron, Deryl Walls," Gallery Dei
Gratia, La Conner, Washington
"Northwest International Art Competition," Whatcom Museum of
History and Art, Bellingham, Washington
Fletcher Gallery, Santa Fe, New Mexico
Quartersaw Gallery, Portland, Oregon

1989 "Boston Printmakers Members' Show," Boston, Massachusetts
"Northwest Printmakers Show," Fine Impressions Gallery, Seattle, Washington
Lisa Harris Gallery, Seattle, Washington
B. Beamesderfer Gallery, Highland Park, New Jersey

1988 "Landscapes," Alonso/Sullivan Gallery, Seattle, Washington
"40th North American Print Exhibition," Brockton Art Museum,
Brockton, Massachusetts

1987 "39th North American Print Exhibition," Danforth Museum of Art,
Farmington, Massachusetts
"Outside Views," Index Gallery, Clark College, Vancouver, Washington
"Landscapes–Thomas Wood, Susan Bennerstrom, John Cole," Whatcom
Museum of History and Art, Bellingham, Washington
Jackson Street Gallery, Seattle, Washington
Gallery Sixty-Eight, Belfast, Maine

1986 Bellevue Art Museum, Bellevue, Washington
"Northwest International Art Competition," Whatcom Museum of History
and Art, Bellingham, Washington
"Northwest Printmakers' Show," Fine Impressions, Seattle, Washington
"Two Printmakers," Carolyn Hartness Gallery, Seattle, Washington

1984 Jay Street Gallery, New York, New York

1983 "Landscape Drawings in Pastel," Whatcom Museum of History and Art,
Bellingham, Washington

SELECTED COLLECTIONS

Ackerley Communications, Seattle, Washington
Active Voice, Seattle, Washington
Adelstein, Sharpe & Serka, Bellingham, Washington
Bellevue Club, Bellevue, Washington
Bonneville Power Administration, City of Portland, Oregon
Brett & Daugert, Bellingham, Washington
Microsoft Corporation, Redmond, Washington
New York Public Library, New York, New York
Trillium Corporation, Bellingham, Washington
University of Washington Medical Center, Seattle, Washington
Westin Hotel, Seattle, Washington
WRQ, Inc., Seattle, Washington

SELECTED PUBLICATIONS

Lois Allan, *Contemporary Printmaking in the Northwest,*
 Sidney: Craftsmen House, 1997.
Lois Allan, *Artweek,* review, April, 1997.
Lee Goss, *Journal of the Print World,* review, Fall, 1991.
Matthew Kangas, *Seattle Times,* review, February 3, 1994.

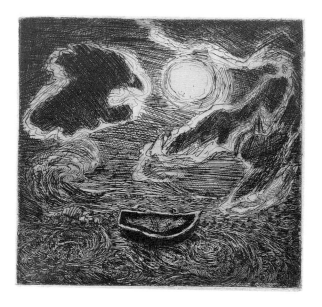

Poet's Journey
1997, edition of 50
hand-colored etching, chine collé
6" × 6"

DONORS TO THE CATALOGUE

Linda Arret
Anita Baker
John and Shari Behnke
Renata Cathou
Mark and Heather Drangsholt
Barry and Diane Faigel
Dianne Goddard and Dennis Edmonds
Barbara and Larry Greenfield
Susan Harris
Anna Harvey and Bill Healey
Ronald Knox
Barbara Lancaster
Patricia Lipman and Mark Stillman
Kevin McNamara
Greg Meredith
Ann Morris
Sharon Nelson and Tom Allison
Jerry O'Leary
Sophia Petrou
James O. Raney, MD
Tom and Dorothy Sherwood
Allen and Kathleen Shoup
Norma and Peter Shainin
Millie Siceloff
John Sisko
Theresa Slechta
James Solimano
Cecile Thomas
Heidi Winterkorn
Judy and Pat Wood
Patricia Woodall

Beamesderfer Gallery
Blue Horse Gallery
Fine Impressions Gallery
Lisa Harris Gallery
Lucia Douglas Gallery
Quartersaw Gallery
Soho Coho Gallery
Whatcom Museum
 of History and Art